Ten Minutes to the Job Interview

Advance Praise for
Ten Minutes to the Job Interview

"A useful resource for learning how to make your first impression count and for the successful, favorable outcome of your interview!"

Robert J. Burg, Executive Vice President
Executive Search Consultant
Ralph Andersen & Associates
Rocklin, CA.

"Ten Minutes to the Job Interview *should be prescribed reading for all college students before they enter the competitive job market."*

Penny Turrentine, Ph. D
Director, West Campus Learning Center
Pima Community College
Tucson, AZ

"It might sound cliché, but, we truly only have one chance to make a good first impression. Nowhere is that more important than in a job interview. Being fully prepared and confident will make a difference. Ten Minutes to the Job Interview *is a must read, especially for those early in their careers or who have limited interviewing experience."*

Scott A. Brockman, A.A.E.
Chief Financial Officer
Executive Vice President, Finance and Administration
Memphis-Shelby County Airport Authority
Memphis, Tn

"Ten Minutes to the Job Interview *is an invaluable resource for every person preparing for an interview; a guide from an expert who has seen it all — a must read!*"

"Ten Minutes to the Job Interview *is a great, thoughtful and comprehensive book that guides the job seeker as they navigate through the interview process. A must have resource for all who want to interview the correct way!*"

"Ten Minutes to the Job Interview *is right on target*"

Ten Minutes to the Job Interview

Your last-minute guide and checklist for securing a position, a promotion, a paycheck

by Rachel Ingegneri

Other books in the
10 Minutes 2 Success series:

Ten Minutes to the Audition
by Janice Lynde

Ten Minutes to the Pitch
by Chris Abbott

Ten Minutes to the Speech
by Vance Van Petten

For more information, visit:
www.Tallfellow.com

Copyright © 2008 by Rachel Ingegneri

Published by
Tallfellow® Press, Inc.
9454 Wilshire Blvd., Suite 550
Beverly Hills, CA 90212
www.Tallfellow.com
ISBN: 978-1-931290-61-6
Printed in USA
10 9 8 7 6 5 4 3 2 1

Dedication

To my husband Joe, who pushed me to finish this book, even when I wasn't ready to be pushed. He is proud of me and my experiences. He should be, he has heard enough of them through the years.

Acknowledgements

Love to:

Leonard Stern, whose vision and ideas gave me reason.

Laura Stern, whose counsel and love has been enduring, therefore deeply cherished.

Grateful Thanks to:

Claudia and Larry Sloan for their tireless support and helpful assistance.

Bob Lovka for his expert ideas and assistance for getting me on the right track.

My family and colleagues who over the years have given me love and respect, have asked for my advice, and even put some of it into practice.

And, last, but certainly not least, to the many, many employees and applicants who unknowingly filled my head and heart with unforgettable experiences.

Introduction

Welcome!

I presume you've selected this book because you have applied for a job or are hoping for a promotion and want some tips on how to conduct yourself during the interview. Or, maybe you are thinking of changing jobs and are anticipating a future interview.

This book is your guide to a successful interview. It tells you what to expect and how to handle it. It comes with a unique, ready-to-use checklist of all the things you need to do — and to remember — on interview day. It also contains instructive chapters to help you project a professional image, organize your thoughts and answer the interviewer's toughest questions. You'll also find resource information on searching and applying for a job and how to write a cover letter and resume. Especially important is the HOW TO USE THIS BOOK section.

I have written the book in down-to-earth, everyday language, and provided some funny (and some sad) anecdotes about job hunter do's and don'ts. The book is intended for the young person seeking the first taste

of the real employment world, the employee wanting to move up the ladder at his or her company, as well as the more mature individual caught in the difficult after-effects of mergers and layoffs.

Whatever your reason, I know this book will provide you with sound advice of how to prepare for the interview and what to do after the interview.

A word of caution for the experienced worker who is out of work for the first time in many years: You are undoubtedly dismayed and heartsick at having to look for a job after toiling for one employer for ten, twenty, even thirty years. You have every right to feel betrayed, angry and at a loss about what to do next!

The best advice I can give you is: Have confidence in yourself! Look back and see what you have accomplished in all the years you worked, see how far you have traveled to be where you are today. When you start beating the bushes, looking for another job, never let the interviewer sense any feeling of anxiety. Remember, you have a lot to contribute to the work world. Do not allow yourself to get caught up in the "poor me" syndrome.

The emotional reaction to losing a job and looking for a new one is easily detected by interviewers if job seekers wear their hearts on their sleeves. If

you fall into that category you must literally train yourself to keep your chin and your thumbs up. You will eventually land another job, and one that will, hopefully, be more to your liking than the last!

When a company I worked for was taken over twenty years ago, some of the most talented people found themselves out of work, some after decades of service. Every one of them eventually found a better, higher-paying and more satisfying job. It isn't guaranteed to happen, but it certainly can.

Whatever your situation, it is my hope that this book will prepare you for all the challenges you may encounter on the way to that new job.

*"People do not lack strength;
they lack will."*

—Victor Hugo

How to Use this Book

A Guide to the Contents

SECTION I: *Prep Work in the Days Before the Interview*
Preparation is the key to a successful interview.
Knowing and learning about the company you wish
to join will be of great benefit to you when you finally
meet the interviewer.

Section II: *The Checklist*
The 10 Minutes 2 Success checklist is a quick
reminder of the twelve (12) points that result in a
successful interview. These are the "Do's and Don'ts"
to review when there are literally "10 Minutes To
The Job Interview."

Section III: *The Details*
This is a detailed explanation of the checklist points,
with advice and tips on how to perform during the
interview. It provides insight into the interview process
and what an interviewer looks for in a job candidate.

Section IV: *Out of Work Due to a Medical Condition!*
This section may not relate to your employment
situation, but if it does, you will know how to

handle a recent illness, injury or accident. Revealing everything is not necessary.

Section V: *Congratulations! You Got the Job!*
Here is some solid, simple, proven advice on what you should do to maintain the job once you've been hired.

Section VI: *Job Hunting/Cover Letter/Resume Writing References & Resources!*
This section lists the best resources for finding the job you want and for learning how to write a cover letter or resume.

SECTION I

PREP WORK IN THE DAYS BEFORE THE INTERVIEW

"I will study and get ready, and perhaps my chance will come."

— Abraham Lincoln

SECTION I

PREP WORK IN THE DAYS BEFORE THE INTERVIEW

Preparation is the key to a successful interview, and it involves more than setting up an appointment and arriving at the company's door on the arranged date and time. Some research into the company at which you're applying will make for an impressive presentation of your efforts! This will also help you determine if the company is a good fit for your employment needs.

Before you apply for any position, ask for a copy of the job description. If you do not meet the minimum requirements or experience for a position being offered, call the company and inquire if your experience and skills would be considered if you do apply. Some companies will not waiver from their stated requirements. Others may accept limited or alternative experience.

Today, with the Internet, it is almost impossible not to find a great amount of information about any organization. One basic fact you should know before

you interview is the correct name of the company, who owns it and how it operates!

Applicants are not expected to know everything about a company but a bit of accurate information mentioned during an interview speaks loudly that the applicant has "done his/her homework" and is very interested in joining the organization.

If you have a computer, input the company's name into a search engine. Most companies have a website. Check it out. You will find a wealth of information.

Research what issues the company is facing. Check financials. Is the company profitable? How long has it been in operation? Has it grown over the years or is it struggling? All that information can help you to decide if that is where you want to hang your hat.

Also search for news stories about the company. You will undoubtedly find recent references on the internet about projects, promotions, financial status and general information that will give you a "feel" for the organization.

If you do not have a computer, you can still request financial reports, advertising material, brochures and publicity from the company itself. These will give you a picture of what the company manufactures, its size,

earnings, growth trends, latest projects and the number of people it employs.

For a personal take on the organization, you can seek out employees of the company. Ask questions, note their reactions and watch their body language. State that you might like to work at that company and listen to how they reply. If you hear an enthusiastic response, that is great. If there is negative talk, be leery.

Ask about the turnover rate. Turnover is a big factor in revealing how the company is managed. If employees are leaving before they have completed one year of employment, that is a good indication of a high turnover rate. That may mean there are problems within the company, poorly produced products, ineffective supervisors, poor management or general dissatisfaction. If turnover is low, that is an excellent sign that the benefits are good, the management is employee oriented and the employees are content and satisfied.

Review everything you have accumulated about the business and pay particular attention to their mission statement, goals and objectives.

During your interview, when discussing the information you have learned, speak about how you can commit to their programs in an assertive manner. Talk about the projects that you have been successful

with in your work history, and provide ways in which you can bring those same successes to the company based on the issues and problems they are currently encountering.

A little knowledge goes a long way toward making you an especially attractive candidate.

SECTION II

THE CHECKLIST

*"The keen spirit seizes the prompt
occasion; makes the thought start
into instant action, and at once plans
and performs, resolves and executes."*
— Hannah More

SECTION II

THE CHECKLIST

1. Dress (and Groom) for Success!
Be conservative in your attire, and neat and orderly in appearance. Look professional, dress for distinction, not distraction Page 27

2. Bring Only What is Required to the Interview!
Don't lug your life around in a briefcase! Bring your charm and a few necessities.

Always carry necessary current identification.

Need a cover letter or resume? Have one prepared.
. Page 35

3. Getting to the Interview!
Know where you are going and how to get there. Now is not the time to get lost, run out of gas or miss a transportation connection! Page 43

4. Arrive On Time or Early but Never Late!

It is common courtesy to be on time.
Promptness is the first sign that you are really
interested in the job Page 47

5. Attend the Interview Alone!

Never bring your moral support to an interview. If
you need someone to hold your hand, stay home.
. Page 49

6. While You Wait!

Other than the usual reason for a visit, the restroom
is a great place to check your appearance, collect
your thoughts and calm your anxieties.

If you must endure a long wait, project a positive,
agreeable attitude. Page 51

7. Meeting the Interviewer/the Interview!

Be calm, confident, and friendly and appear genuinely
interested.

A half-hearted handshake will not do Page 55

8. Handle the Tough, Personal and Problematic Questions with Confidence!

Answering seven categories of in-depth and personal questions ranging from why you're out of work, why you believe you are ready for a promotion, why you should be hired, to how you'd handle workplace situations, and what you expect to be paid . . Page 63

9. Your Turn!

At the end of the questioning, the interviewer may ask if you have any questions!
Ask them intelligently or make a positive "closing statement." . Page 81

10. Make a Timely and Polite Exit!

Be alert to when the interview is over. Here's how to tell, and make a polite exit.. Page 85

11. No After-Interview Regrets!

Don't fret about what you should have, could have said. Page 87

12. Follow-Up Do's and Don'ts

A thank-you note is a do. A call to the company may be a don't! . Page 91

SECTION III

THE DETAILS

*"A thing of beauty is a joy forever;
Its loveliness increases; it can never
pass into nothingness."*

— John Keats

SECTION III

The Details

1. Dress (and Groom) for Success!

If the initial impression you create is negative, the interviewer will be hard-pressed to think of anything else!

You don't have to look like you just stepped out of a fashion magazine, but you should consider how you will appear to the interviewer. That first look will create either a positive or negative impression.

It should go without saying — before going on an interview, bathe! Clean your fingernails. Brush your teeth.

The annals of interview history are filled with horror stories of applicants who literally made the interviewer feel ill — I am one of them — due to a nauseatingly unpleasant body odor.

After you bathe, or shower, be extra careful of
what you put on your body. Drenching yourself in
aftershave or strong-smelling perfume can be very
distracting for an interviewer. Also, many people
are allergic to certain heady, intoxicating scents.
Water and deodorant are the two most practical
commodities we have today. Use more of the water,
a reasonable amount of the deodorant and much less,
if any, of the bottled fragrances!

A rumpled look is unforgivable in today's business
world. If you are not neat and orderly in your
appearance, you will create the impression that you
are probably untidy in your work habits — even
though that might not be the case.

The basic rule of thumb when interviewing for
any job is: Dress Professionally – even if current
employees have a tendency to look casual or even
sloppy. We have come a long way in relaxing our
wardrobes but not so far that business attire has
been replaced by outlandish, gaudy, tasteless garb.
There are many, many companies that still insist on a
professional look!

It all comes down to this: Wear sensible, practical,
washed and ironed clothes!

What to Wear!

For men: A clean shirt, a nice pair of slacks, a tie and sports coat or a suit, if appropriate, and polished shoes. For women: Wear something conservative, like a neutral-colored dress, or a smart-looking blouse with slacks or a professional business suit.

What Not to Wear!

Ladies, no sandals, sneakers, shorts, jeans that reveal your hip bones and your thong undergarment or skirts that just barely cover the cheeks of your derriere! And, be careful of too much cleavage. Limit your jewelry to something simple. No dangling earrings, heavy necklaces or rings on every finger. In an interview situation, they distract from you and what you're saying. And don't pile gobs of makeup on your face! Looking natural is wiser for a business interview than looking like you are ready for a photo shoot.

A young woman arrived for her interview wearing black fishnet stockings, five inch black suede strapped shoes and an extremely short, black flared satin skirt. The outfit was topped with a red see-through blouse over a black bra. Inappropriate attire for an interview unless of course you are applying for a hostess position at a bar or strip club.

Gentlemen, your favorite shiny purple or chartreuse sharkskin suit may be just the ticket when you are prowling down Main Street with your buddies, but

keep that outfit in the closet. Also, no sneakers, jeans, pants positioned below your buttocks that reveal your undergarments, multiple chains, and an open-to-the-waist shirt, and no T-shirts with your favorite rock star's picture, your high school/college logo or a "funny" saying on them!

I interviewed a young man who had a toothpick hanging from his mouth. He wore a T-shirt with an expletive painted across his chest, torn jeans and a pair of rubber thongs. Another example of inappropriate attire for an interview. No, he did not get the job!

Body Jewelry and Tattoos!

Whether you are male or female, if you wear a ring in your nose or multiple sets of rings on your ears or eyebrows, or a cherished silver ball on your tongue, remove them for the interview!

A colleague once said to me, "During interviews my mind wanders and I ask myself questions like: 'Does that ring in her nose get in the way when she has a cold?' or 'How does he eat corn-on-the-cob with that ball on his tongue?'" Don't let this happen to you!

Unless you're interviewing for something in the rock or rap music world, take off all body jewelry until you get hired. After that, wear simple jewelry until you see the type of accessories the rest of the

work population wears and figure out what is actually acceptable at that place of work.

Do you have tattoos on your neck, face, arms and legs? A little preliminary observation of employees at the company where you are interviewing can offer clues. One employer may not be the least bit rattled. Another may have strict rules against tattoos. Depending on the nature of the business, tattoos hidden under clothing might be okay, but those visible to clients or customers may not.

Your best bet is to conceal tattoos if you can. If you don't want to compromise your chosen lifestyle for an interviewer or for a company, forget the interview!

No Hair-Raising Interviews!

Avoid the "bed head" look. You never want to appear as if you just rushed out of the house to get to the interview. It's best to tame your wild hair style. As I've said before, visual distractions take away the value of what you are saying!

I interviewed a bright applicant who kept pushing his long, straggly hair away from his face. That was a big distraction. Each time he turned or bent his head, his hair went flying!

Men: I encourage you to trim those long locks or tie your hair back in a ponytail. Interviewers want to see the eyes of the applicant. Get rid of any grizzly look. Your beard and facial hair should be neatly trimmed.

Women: Do something with those tendrils hanging all around the front of your head, covering your face and eyes. All those pieces of hair floating around your face are extremely disruptive and can interfere with one's thought process. This type of hairstyle is lovely for a party, the prom or a date but not for an employment interview!

Multi-colored hair is quite acceptable in many places today, but it may be frowned upon in certain business environments. If you do have four different colors in your hair, decide on one for your interview and let it be a basic brown, black, red or blonde. If you are lucky enough to land a job, keep the one color until you figure out what is acceptable at work. Don't be the first to break the barrier into the bizarre!

My first encounter with spiked and colored hair was when I interviewed students from a local college. The fourth candidate came highly recommended with a 4.0 grade point average. Her hair was long and flowing with multi-colors of blonde, black and brown. The amazing part of her hair style was her bangs. They literally stood up almost a foot from her head. Her potential to be a good

employee was excellent, but her appearance would have been distracting in the workplace!

One last bit of advice concerning dress and grooming – have everything you are going to wear laid out the night before the interview. And be certain to get a good night's sleep. Dark circles under your eyes and constant yawning during an interview can be very troublesome for the person sitting across from you!

"Joy is not in things, it is in us."

— Richard Wagner

2. Bring Only What is Required to the Interview!

In larger companies, there is usually a first interview by an administrative assistant, a secretary or a Human Resources employee. That person does a "screening interview." Then a second or third interview may be scheduled with the person or persons who will actually make the hiring decision.

A good question to ask when scheduling your interview appointment is: "What should I bring to the interview?" The person you are speaking with will let you know what would is advisable to carry along.

Need a Cover Letter or Resume?
If you are told to send a cover letter and/or a resume, or to bring them with you, they will be your opportunity to introduce yourself. They should be written so that you arouse enough interest for the person reading them to want to meet you and know more about you.

The cover letter should provide brief but relevant information of how your experience and background

will meet the functions of the position. When sending a cover letter or resume to an employer, always mention the position for which you are applying as that employer may have listed several positions; if you do not specify which one you are interested in, the letter may be disregarded.

A very brief intro might be "I am very interested in your internet (or newspaper) advertisement for the position of _____. I have six years of related experience and it is my hope that we could meet to discuss my experience and background."

Take extra care in the preparation of your letter. It should be one page in length. A resume should be no more than two pages and the letter and resume should be error-free.

Here is a good tip about cover letters and resumes, strictly from an interviewer's point of view. They should only be printed on white, off-white, grey or cream colored bond paper. Those shades are easy on the eyes and present a very professional appearance.

I received a resume in a dazzling, bright blue folder with a 2" by 4" airplane attached to the outside and bright blue paper on the inside. Another was filled with pictures of buildings the writer had designed. Unfortunately, the pictures were copied on poor

quality copy paper and were blurred and fuzzy. Each of these resumes certainly caught my eye and turned me off!

Your resume should contain the "nuts and bolts" of your background, as well as pertinent information regarding the job you are seeking. Abstain from listing personal information, such as your marital status, number of children, etc. Include your work history, your achievements at prior jobs, your education and your objective in applying for the specific position.

Do not embellish your education, your experience or your skills. You should not assume that what you write will not be checked. Most employers today verify resume and application information.

The "nuts and bolts" of how to write a cover letter and a resume is another book in itself. There are excellent resources available for you to actually write a cover letter or resume. (See Section VI for resource information).

What Not to Bring!
If you know ahead of time that your interview is the first of several, do not bring a portfolio or samples of your writing or copies of your video or bound copies of the many seminars you have attended.

Preliminary screeners do not have the time to wade through volumes of scintillating poems or pictures during the first screening interview. Their task is to validate your experience and work history, ask questions regarding any holes in the time lines, fill in any blanks, make a determination if you will fit into the company and either decide to have you continue with the recruiting process or reject you.

All that "extra stuff" will quickly frustrate a screener who is working on a very tight schedule. If you make it to a second interview, that may be the time to bombard the decision maker with examples of your artistic ability. Dragging all your life's work in a big valise may kill your chances for a second interview. Save the good material for the person who needs to see it.

A screener friend was conducting a first interview and found herself the victim of an applicant who brought along a poster pad and marking pens. He set up his poster board and graphically illustrated his work history with a variety of brightly colored pens. No matter how hard the screener tried, nothing could stop the demonstration. The applicant had a plan and a script, and could not be dissuaded! Not a wise plan! The applicant was eventually dismissed and was not asked back for a second interview!

Though you've been cautioned not to lug your life's story to the first interview, there are some very important items that you should bring with you. Government regulations require employers to verify certain documents before hire. If the interviewer can hire you on the spot and you do not have the necessary identification, you may lose out on a position.

What to Bring!
• Do bring a pen or pencil and a small notepad. You might want to jot down names or numbers or some specific information that may be of interest at a later time.

An applicant came into my office and set up housekeeping. Onto my desk he placed a huge trunk-like suitcase. Out came multiple pads, books, loose-leaf binders, rulers, erasers and several pens and pencils. Then after several minutes of arranging and re-arranging his belongings, he looked at me, smiled, and sat down for his interview. Unfortunately for him, my first impression was a negative one!

• Do bring your drivers license and your social security card. If you do not have a drivers license, the original of your birth certificate, bearing an official seal, your unexpired or expired passport, your voter registration or military or school ID card will be acceptable,

provided one of those contains your photograph. There are a number of identification cards that are also acceptable, such as, a Native American tribal document, a drivers license issued by a Canadian government authority or an ID card issued by a federal, state or local government agency, again, provided it contains your photograph or information listing your name, date of birth, gender, height, eye color and address.

If you are from another country, your "green" card or papers that indicate you can work legally in the United States must be current and not about to expire.

Even people already working need to keep their documents current. A female employee's work papers expired and the employer had to let her go until she could update her work status. It was an unfortunate situation because she was a very good employee, one the company regretted terminating!

Assemble only the necessary materials the night before your interview and have them ready to go on interview day.

References!
Another item to bring "just in case" is a list of references with home and business phone numbers included. In larger companies, references are generally not needed until a decision to hire has

been made. In smaller companies, the list may be requested during the first interview.

Obviously, you should not use a close family member as a reference. Choose three or four people you know will speak positively about you, your relationship and your work experience. Pick someone who can verify your positive work background — a friendly former supervisor, a current long-time personal friend or a current neighbor, someone you lived near for a very long time.

Contact your selections and ask their permission. Listen for hesitations and don't be hurt or angry if you sense reluctance. Most people who have had a good working or personal relationship with you will be happy and proud to support you. Do discuss your goals and reasons for your interest in a particular position.

When an interviewer made a call to a supposed friend of an applicant, she got an earful of juicy information about the applicant's repeated failures with drugs and alcohol and his domestic and financial problems. Be sure of the references you use. Some people, when they are told they are speaking in confidence, will believe they have license to tell all, and believe me they will!

Formal Oral Board Panel!
If you are appearing before a formal oral board panel

process, for an executive, management or public safety position, do not attempt to dazzle them with bound copies of your resume or application. Those have generally been provided beforehand by the Human Resources Department and will only be excess baggage for the panel members.

3. Getting to the Interview!

Don't wait until the day of the interview to figure out where you're going and how to get there! Even if you think you know the "where" and "how," do some advance planning. This is not the time to get lost!

Many an interview has been postponed or canceled because the applicant was not aware of or "forgot" exactly when and where the interview was to be held. The person setting up the interview should provide all that information. But don't rely on someone else who may be rushed or mired under piles of paperwork to provide you with everything you need. To be absolutely certain, don't hesitate to ask for specific instructions.

You need to know the exact time of the interview and with whom you will be meeting. What is the street address? What are the cross streets? The interview may take place in a business park where many buildings are spread over an area. What does the building look like, and, most importantly, what is the best way to get there?

An applicant called the interviewer two hours after his

scheduled appointment, claiming he left the directions
at his girlfriend's house. When he went to retrieve the
directions it was too late for the interview. You can be sure
there was no appointment for another interview!

Car or Public Transportation!
If you take public transportation, be certain
that buses or trains or subways will get you to the
interview on time! Obtain specific information about
bus and rail station locations and where the nearest
stops are.

If you are driving your own or someone else's car,
check your gas gauge the night before and fill up if
needed. On the way to the interview is not the time
to be lugging an empty gas can to the nearest service
station!

If someone else is driving, call the evening before
the interview to confirm exactly what time you want
to arrive at your destination and be certain that
person has gas in the car.

Have all that important "stuff" taken care of the day
before your interview. Don't wait until the last minute
when you are already feeling nervous and anxious.

An interviewer will not be impressed by an applicant
who can't find the right location. If you didn't do your

homework before you're hired, what does that say
about your organizational skills?

"I owe all my success in life to having been always a quarter of an hour beforehand."

— Lord Nelson

4. Arrive On Time or Early but Never Late!

It is common courtesy to be on time for any appointment. Showing up late for a job interview is an absolute no-no. It is better to be a little early. If you are, you will have time to relax, get over your jitters, collect your thoughts and be in better control. If the interviewer is running ahead of schedule, he or she will be pleased to see that you've already arrived. Your promptness will be the first sign that you are truly interested in the job. If you arrive late, the feeling will be the exact opposite and may be interpreted as a red-light signal that you may well arrive late at work.

If you are unable to keep your appointment for a very valid reason, call and let the interviewer know—well before the time of your interview. Calling a half-hour later will guarantee you will not get a second appointment.

One late arrival for an interview told me he was "held up by a funeral procession." Another said, "My dog took my shoes and I couldn't find them." Lame excuses only make the lateness worse!

If you have a legitimate reason for missing the interview, ask to have it rescheduled. If you handle yourself properly, your request will probably be granted. Obviously, if your story sounds bogus, you can forget about another interview!

Another important point about postponing an interview: If you are sick, have a cold, a fever, anything contagious, it makes sense to let the interviewer know the entire situation. Sitting opposite someone who is sneezing or coughing is an experience an interviewer can do without. Stay home when you are sick! The interviewer will be forgiving and grateful!

5. Attend the Interview Alone!

Do not bring a friend or your mother or your spouse
to an interview! Yes, your friends love you and want
you to succeed, but they should be providing moral
support from a distance.

*One of my more "interesting" interviews was with a
high school student whose father insisted on sitting in
on his son's interview. The father tried to answer all my
questions! Only after turning my shoulder to him and
ignoring him was I able to direct the questions to the
applicant, who was visibly embarrassed.*

If someone drives you to an interview, he or she
should drop you off and stay away for at least 45
minutes. Tell your friend to get a cup of coffee
somewhere or go window shopping — anything other
than cluttering up the company's waiting area.

Can't take a step without your beloved boyfriend or
girlfriend? Then how will you convince an interviewer
that you can work on your own? And, having your
buddies hang around the reception area during your
interview is inappropriate and very unwise!

Don't bring your children to an interview. If the babysitter doesn't show up, or if you can't leave the kids with grandma or friends, call the interviewer and ask to reschedule. Never leave your children home alone.

6. While You Wait!

Use the Restroom to Your Advantage!
The restroom is your launchpad to the interview. Use your waiting time to fine-tune your appearance and put on a confident face. In the company reception area and in the waiting room, you will be on display and making an impression.

Check your hair and your teeth. Be sure there is no lunch spinach stuck to your teeth, no cottage cheese dribbling down your chin or bread crumbs on your beard, moustache or tie. And, please, everyone, check your nostrils. A piece of dried nasal mucus hanging from, or about to drop from, your nose is not a pretty sight!

If you are chilled from nervousness, run your hands under warm water. That one little action can warm your whole body. If you are warm from anxiety, wet a paper towel with cold water and place it on your wrists for just a few minutes. You will feel cool and refreshed.

Are you still nervous? Try the actor's trick: BREATHE!

Take very deep breaths and exhale forcefully. While you are releasing your breath, think to yourself, "This will be a great interview" or "I can do this" or "I know I am prepared" or "I am going to be relaxed!" The exercise will release neuro-transmitters (endorphins) that occur in your brain, helping to relieve the jitters and butterflies.

Finalize Your Look...Breathe In...Breathe Out... Think Positive Thoughts!!

Courteous Behavior!
Think of your interview as beginning in the waiting room or receptionist's lobby.

Present yourself in a manner that will do justice to the time and effort you have spent in making yourself presentable and employable. And don't spoil it by being discourteous or disagreeable in any way.

Your calm, cheerful and positive demeanor can leave a good impression on the receptionist and any other employees who may walk through the waiting room. Sometimes those people are intentionally sizing up the candidates to observe how they behave in the waiting mode.

Receptionists and other select employees can be very intuitive about people. They can spot a phony a

mile away! Most receptionists have developed great instinct about applicants and take particular pleasure in forming a critique of people who pass through the lobby.

Be polite and cordial to other people waiting in the lobby.

Don't be a Bore!
Bragging about your extensive job history or your economic wealth will probably not intimidate the other people but it will certainly bore the socks off them! Think twice before you attempt to be the "belle" or the "beau" of the waiting room. If you are overly loud or dominate conversations or talk down to the other people, that information may very well be conveyed to the interviewer.

A savvy receptionist I worked with witnessed an applicant boasting about his accomplishments to an unfortunate captive audience in a lobby area. He was overbearing, rude and particularly annoying. Following his formal interview, the receptionist commented to me, "Don't hire that crude, conceited, boring man!" The receptionist's critique confirmed my opinion.

Be Cool!
Interviewers plan ahead with scheduled times for each applicant but there are always situations that can

throw the schedule off-kilter.

Have you been sitting in the lobby for almost an hour? Have you been moved from one office to another, or shuffled from person to person? These are all annoying circumstances, but stay cool. Over-reacting or demonstrating a visual show of displeasure may not bode well for you getting a job with that company. Be patient, tolerant and understanding, and rise above the situation!

I once had to move an applicant from a spacious conference room to a smaller room to accommodate a large group of company visitors. The applicant became visibly upset and audibly unpleasant. Although I apologized, the applicant would not accept the apology. She became unreasonably loud and expressed, by way of several expletives, that she was "not there to be pushed around by anyone." She obviously was also saying that she didn't want the job!

A final word on waiting: If the interview is delayed and you cannot wait much longer, politely mention it to the receptionist or someone else in the company who can alert the interviewer.

7. Meeting the Interviewer/the Interview!

Put your best self forward when meeting your interviewer! In any interview, you have to be able to sell yourself. The way in which you handle yourself during that session will decide whether you get the job or not – even if you are overqualified, under-qualified or if you have no work history at all.

First impressions count, so be calm, speak confidently, be friendly and appear genuinely interested in the company and the interview opportunity.

No Half-Hearted Handshake!
Make your initial contact with the interviewer positive. A half-hearted handshake will not do! Be cognizant of how you shake hands. Is your handshake limp and lifeless? Do you offer only two fingers? Or do you grab the other's hand and crush it and nearly jerk the arm out of the shoulder!

Your handshake should be firm, not so hard that it would leave a wedding ring mark imbedded in

the interviewer's finger, and not so weak that the interviewer is calling for medical assistance — for you!

If, for some reason, you prefer not to shake hands with the interviewer, say so. Say something pleasant like, "Please don't think I'm rude. I prefer not to shake hands but I am very pleased to meet you!"

The Interview!

When asked questions by the interviewer, be honest and genuine, and avoid the appearance of conceit. Be alert and responsive! You don't want to make the interviewer struggle to extract an answer from a blank, staring face.

In your responses, eliminate the ums and ahs and the empty repeated words such as, "you know," "like" or "basically." And, you don't need to repeat every question word for word before you respond. Look upon the exchange as a natural conversation. It's not an interrogation!

Think Before You Respond!

When a question is posed, listen carefully. Many an applicant has given answers to questions that were not asked! Pause if you have to, collect your thoughts and express them in a confident, easy manner. Thoughtful answers are much better than hastily made-up ones with no content.

An interviewer asked an applicant what she preferred most to do with her free time. Without thinking, the applicant blurted out that she "really hates working and would like to be sand-bumming somewhere on the big island of Hawaii." She didn't get the job!

While chatting with the interviewer, be natural and relaxed in your posture. Make direct eye contact. You may be nervous, but avoid demonstrating that anxiety by fidgeting or stiffening your body… or by crying!

I interviewed a young man who was so nervous he burst into tears when I asked him to talk about himself. Another applicant began talking about the details of her preparation for the interview before I asked her to be seated. She rambled on about her personal and family life, finally, took a breath, and acknowledged my presence.

A last bit of advice: Be careful not to reply to anything with "To be honest with you…." or "To be really truthful…." Were you not honest and truthful with all your other answers?

Make the initial contact memorable, but not for the wrong reason!

Tell Us About Yourself!
One of the first questions that may be asked is: "Tell

me (us) something about yourself!" The best way to respond to that type of question is to be very brief with any personal information and get right into what will be most important to the interviewer — your employment information.

You may say something like, "In my last job I excelled in..." and provide facts about how you achieved a goal, how you reduced an overhead, how you solved a work problem or how you saved the company money.

If you have been in the employment arena for many years, you have work-related successes and accomplishments you have probably forgotten:

- How many projects have you worked on over the years that made a significant impact on the company?

- What was the project and what were the results and benefits of that project?

- Did you devise a method for counting the number of widgets in the warehouse?

- Were you instrumental in completing a budget that saved the company x amount of dollars?

These are the types of accomplishments you should discuss. Remember to focus on how relevant and

beneficial they could be to the department and company and job for which you are applying.

High-School or College Graduate!
If you are a recent high school or college graduate, focus on your successes and accomplishments at school, and your extra-curricular, club and community participation. Most volunteer or group efforts are for the benefit of others and/or the community. In many ways, those efforts reveal much about your ability to join, and your capacity to care, about the welfare of other people.

How you functioned within a group is a powerful sign of your teamwork potential or, even better, your leadership ability.

As for school accomplishments, you should talk about:
- What subjects you took in school and why? Don't forget to discuss classes such as typing, shorthand and computer labs that might relate to the job for which you are applying.

- What else you have learned that you can apply to this job.

- What awards you have received.

- What particular speaking, debating, musical or theatrical talents you have that received school acclaim.

And, there's babysitting experience!

Babysitting is not an easy task. Taking care of someone else's children is tough work. It takes patience, tolerance and an understanding of how to remain calm when the baby is crying or the children are tearing the house apart.

Don't Overlook Your Participation in Non-work Areas:

- Are you a community volunteer?

- Have you held office in or belonged to a non-profit organization or fraternal club or group?

- Did you chair a committee for contributing funds to people in need?

- Were you the media representative of your organization, or did you collect raffle gifts for its annual fundraising?

List all such achievements on paper, noting dates and details, and carry that list with you. A word of caution: Carry that list but don't read it verbatim, use it only as a guide.

The "tell me (us) about yourself" question usually provides you with the first opportunity to talk about your successes and accomplishments. Use it!

Tests Make You Tense!

If you are asked to take a typing, computer or questionnaire test, take a few minutes to relax. Many people freeze when asked to complete a test. If you are one of those people, it is important for you to pause and gain control of your emotions. Remember the actor's trick—breathe and think positive thoughts. In your mind's eye say, "I can do this!" As hard as it may seem, you can ace that test if you remain in control. Being in control may make or break your chances of getting that position!

"Tisn't life that matters! It's the courage you bring to it."

— Hugh Walpole

8. Handle the Tough, Personal and Problematic Questions with Confidence!

The how, why, what, where and when of your background will be completely explored by a good interviewer. Also, the interviewer will be trying to determine how your abilities and personality will blend into his or her work environment.

A good interviewer will cover things that fall into seven general closely-related categories. These are listed below to serve as your last-minute reminders before going into the interview. You can put your best foot forward by being aware of these seven categories of possible questions:

A. Questions About Your Work History
The interviewer will definitely ask about your past work history:

- How many jobs have you had?

- When did you work for company B, from what starting date to what ending date?

- Why did you leave that company?

- What were your tasks? To whom did you report?

- Did you work with other people or did you work alone? Why?

Are there gaps in your work history? Be prepared to discuss why.

And, what did you do during unconnected time periods? Be ready to briefly explain the holes in your work history, but don't go into long-winded details about your trip abroad or your family obligations. Stating simply why the gaps occurred is enough. Do not take up the interviewer's time with insignificant ramblings.

Those questions will likely be on the agenda. The how, why, what, where and when of your background will be completely explored by a good interviewer.

So, prior to the interview date, make a list of everything you have done from the beginning of your working life to the present. The time to call upon this Rolodex of your work life is not when you are stressed, but when you have the time to think clearly and comprehensively. Depending upon how long you have been in the work environment, you may not need to talk about things you did in high school or college!

Remember to focus your successes and accomplishments on how relevant and beneficial they could be

to the department and company and job for which you are applying.

Also, be prudent with how much and the kind of information you provide about your personal life. Completely unsolicited, a young cafeteria worker once told me that she "caught crabs" from the toilet seat at work! Too much information!

You will shine your brightest if you are adequately prepared. This section is your "heads-up" — a preparation and guide to the more difficult and problematic questions you may be asked, along with advice on how to respond.

Be prepared. Never blurt out the first thought that pops into your head — it could be the reason you didn't get the job! Read through this section and think carefully of how you will respond.

B. Questions About Your Personal Strengths and Weaknesses

Maximize your strengths and minimize your weaknesses! Concentrate on the positive and talk about the steps you are taking to overcome the negatives. Whenever you discuss strengths and weaknesses, speak in a self-assured, confident manner. Keep your comments brief, but talk again of what you can do for the company or how your

background and experience will be of benefit to the job and the organization. Say only what you believe you are capable of doing. When you are finished with your statement, thank the interviewer or panel for their time.

Talk about your patterns of success, your academic accomplishments, your leadership qualities, your flexibility, your adaptability and your ability to blend in and mix with all types of people. Reveal your assets and interests in a way that the interviewer can see only confidence and optimism.

If the interviewer comes right out and asks you about your weaknesses or inabilities, concentrate on the positive and talk about the steps you have taken to overcome any deficiencies. "Over the years I have been aware of my weaknesses and inabilities, I have worked very hard to overcome them." To avoid further questioning about your shortcomings, you may want to expand on the above response with, "I realized at a very early age that I had a tendency to (whatever the weakness was). As I have gotten more mature I have learned (how did you solve the problem) and I am very proud of being able to overcome a weakness!"

Weaknesses may be personality flaws, such as, procrastination or temper flare-ups, lack of

concentration, etc. Inabilities are talents not yet acquired, skills not yet learned and education not yet completed. Abilities are smarts and know-how that can be acquired along the way. And, as we proceed along the path of our work life, we discover talents and abilities we do better and some we don't do as well.

There are ways to maximize your strengths and minimize your inabilities. The first thing you must do is write your strengths and inabilities on a piece of paper. Be honest with yourself. Then figure out ways to enhance the strengths and turn the not-so-strongs into positives.

Another good way to answer the question about weaknesses or shortcomings is: "Before I applied for this job I realized that my computer skills were lacking so I took a course in (whatever the need might be, i.e. PowerPoint, Outlook Express, Excel, etc.)"

Give some thought to your shortcomings. They may not all be negative!

- "I get caught in the trap of never being able to say no." That is not necessarily a bad thing, it means you are helpful to others!

- "I am a perfectionist." You accomplish your given tasks with accuracy!

- "I can be too hard on myself." That is because you expect only the best of yourself!

Those types of statements are turning your short-comings into positives. They are weaknesses laced with the desire to learn and grow. You should be able to discuss your frailties with confidence and self-assuredness, not with arrogance or conceit or a defeated attitude.

Don't overlook your strong points!

- "I am friendly, easy to talk to."
- "I have a way of putting people at ease." How?
- "I catch on to tasks quickly and complete them on time."
- "I have multiple skills." What are they?
- "I am proficient on a computer."
- "I am a good listener, a good writer."
- "I can follow directions."
- "I am flexible."
- "I am self-confident."
- "I am reliable and dependable."
- "I have devised a way to effectively deal with difficult people." How?

The above should help you focus on your strong attributes and talents. Talk about them and, most importantly, explain how you think they will benefit the job, the department and the company.

C. Questions About "Hypothetical Situations"

Today's interviews are broader in range than those in the past. In the new millennium world of employment, many interviewers present hypothetical situations to job candidates and evaluate applicant responses as indicators of how the applicant will handle such situations in the real workplace. Below are some typical questions with responses you may find valuable.

- "Suppose you have been given a task from your supervisor that will create an unnecessary negative outcome?"

A good response would be: "I would discuss it calmly with my supervisor and carefully point out why I think it will cause a problem."

A follow-up question may be, "Suppose your supervisor tells you to do it anyway?" Your response would be along the lines of: "I would perform the task unless it created an unsafe situation for me or my co-workers. Then I would talk to my supervisor again. If he/she wouldn't listen I would have to go to his/her supervisor and explain my concerns."

- "How would you handle a situation if you were aware that a co-worker was stealing on the job or cheating on his time card or using drugs on the job?"

Don't say you would take care of the problem yourself! These are concerns where you must immediately speak with your supervisor. Your response to that type of question should be: "If I observed that type of behavior, I would immediately speak to my supervisor, or if there is a Human Resources department I would speak with one of the representatives and tell them exactly what I know."

- "How would you handle a person who is angry/upset/critical of your company or you?"

You may be asked this question in a variety of different ways but your response to how you handle difficult people should always be the same: "I would remain calm and ask the person what I can do to help. It is important that I remain calm and demonstrate to the person that I am interested in solving his or her problem."

When asked to describe a situation involving conflict with another employee, and how he actually handled it, an applicant's reply to me was: "I was right and he was wrong and I told him so in no uncertain terms. He was a real jerk!" An absolutely wrong answer! Bad-mouthing any person during a job interview is unprofessional and a major taboo!

- A situational question with a personal bent may
 be: "How have you handled disappointments/
 failures in your chosen career?" The answer here
 is basically the same as the previous one. You
 may have been disappointed and you may express
 that dismay but spend more time talking about
 how you personally and professionally handled
 the situation.

One of my peers always asks applicants "What
would make you fail?" The best answer to that type
of question is: "I don't see myself failing" or "I have
confidence in myself so I don't intend to fail!"

Many applicants respond with a specific reason: "my
lack of a college degree," "my inability to control my
temper" and a dozen other ones! Reasoning why you
might fail is a sure-fire way not to get the job!

D. Answering Classic Questions About Your Ambitions, Abilities and Adaptability

In addition to the hypothetical questions, there
may also be queries about your ability to perform
in the workplace, your goals, and what you learned
previously that will impact this job.

If you are applying for an executive position, there
will be questions about budgeting, supervising
employees, fiscal responsibilities and certainly job

related questions. You must brush up on your skills and experience so you can answer those questions intelligently.

- "How will you perform in strange and new surroundings?" Your response can be: "With flexibility and adaptability. I usually roll with the punches."

- "How is it that you want to leave your current position and company?" This definitely will come up if you are still working for another company. A good response would be: "I've enjoyed the people I work with and the job itself. I have learned a great deal from that job but I am ready to accept more responsibility and new challenges."

- Here is a classic question: "Where do you want to be in five years or ten years?" A thoughtful response could be, "In the same type of work, but in a higher position, perhaps supervising people, and utilizing the skills I have acquired over the years."

- Another timeless query is: "How do you deal with office politics?" Positive remarks such as this would be in order: "I am on good terms with

everyone. I don't take sides and I stay away from gossip and discussions with my co-workers that may cause problems in the workplace!"

- This is a question that will give you pause unless you are prepared to answer it: "What have you learned from your last position and how will you apply those lessons to a job today?" Keep things positive: "I had a really smart supervisor who taught me everything he knew about (whatever, but make it work-related) and I used his teachings to enhance my own productivity and skills."

I once asked a woman to describe her current supervisor. Her immediate response was, "He is a lousy boss and that's why I want to leave that company!" Wrong answer!

If you don't like your supervisor but he/she does a fairly good job and has positive working relationships with his/her peers and subordinates (maybe not with you), there is no harm in saying: "He/She is good at his/her job and gets along with his/her peers and subordinates, and I've learned a great deal about (whatever) from him/her."

As far as you are concerned, his/her management style may be lousy, but you did not lie. You probably did learn a great deal — to be nothing like him/her!

All of these questions deserve honest answers. Just because I have given you good responses, you should not use them word for word unless you believe what you say. Remember, most companies have a probationary period and if you have given false or disingenuous answers, you will be found out!

E. Discussing Salary and Compensation Needs

Somewhere in the interview you will be asked questions regarding your current salary or what you would expect to be paid should you be hired or promoted. This is always a touchy area and should be handled carefully. The key is answering honestly while conveying your flexibility.

Questions like: "What are you being paid in your current position?" or "What wage were you making in your last position?" are bound to come up.

Whatever that salary or wage is or was, remember, answer with honesty and flexibility: "I currently earn (whatever the figure is), however, I feel I am worth much more because… "(respond with confidence, not cockiness about your skills and why you think you are worth more). You can also say that you are willing to negotiate and that you are flexible in terms of salary.

If you have predetermined what you will accept, it

may be wise to raise that figure just a hair or maybe a little more than a head. In any case, if the wage is negotiable, then you can dicker about what is acceptable to you. In that way, you are demonstrating your ability to work with the company. If you can't be flexible and you must earn a particular wage, then convey that message with some reasons why you cannot accept an offer that would be below your economic requirements. Don't just say "No, I can't accept that wage" without some explanation of why.

When we moved from back East to Tucson in 1955, I applied for a secretarial position at an architectural firm. They offered a lesser wage than I was accustomed to receiving. After I explained, in great detail, my skills and background, I got the job and the wage I requested! I am living proof that it works!

F. Why Are you Job Hunting? Why Here?

Resigned from your last job? Terminated? Be honest because the truth will come out! Whether you left a previous position involuntarily or of your own free will, talking about those events may be difficult, but you must and you must be honest. Trying to fib your way through an interview will not fool the person sitting across from you.

Be brief and candid, and my earlier statement needs repeating: Do not bad-mouth your former employer

or supervisor. Speaking ill of anyone during an employment interview is politically incorrect and a sure way to sabotage your chance of getting hired.

Don't whine about how awful the supervisor treated you or how you were misunderstood by your co-workers. And, stay away from the word "fired"— your anger or frustration will come through in your voice.

An interviewer was speaking with a well qualified applicant on the phone. His reason for wanting to leave his current position was that he "disagreed with his company's philosophies." This comment was not bad-mouthing; it was merely stating a valid reason for wanting to leave that company.

If you were terminated for cause, talk about the reason.

Focus on what you learned from the experience and how you have applied it to your life. For example: "I was released from a job when I was experiencing car problems. I was late for work more often than I wanted to be and that experience has taught me that my car has to be in good working order if I want to fulfill my commitment to my employer."

Another statement might be: "I was separated from

my job because, at the time, I couldn't seem to do the work properly. My supervisor expected more from me than I able to produce. I've looked at how I could have done better and I've improved my clerical (or whatever) skills and am now sure I'm much more effective and productive."

The real technique here is to look deep within you and take some responsibility for what happened. What could you have done to make the whole situation better? Then talk about the lesson learned.

A high school student who was hired to wash dishes in the company restaurant resigned after a few days, saying, "I was hired to wash dishes, not pots!" Another high school student I interviewed said, in no uncertain terms, that he would never work for minimum wage.

You can also speak about looking for different and new challenges.

For example: "Although I enjoyed my job at Company B, I felt that I had more to offer. There was nowhere for me to go in the company so I left to explore other possibilities" or "I know many people believe that you shouldn't leave one job without having another, but I wanted to put all my efforts into finding a really good position."

An accomplished interviewer I know asks her applicants, "What's your Plan B?"

If they respond that they have a "Plan B" and elaborate on it, what they are saying is that they don't have confidence in themselves to succeed in the interview! This is not the time to talk about any other plan but to win the interview and get the job! Always talk about succeeding, not failing!

G. Talking About Why YOU Should Be Hired

One of the last questions you may be asked is: "Why do you want this job?"

When you reply, focus on the challenges of the position, how you look forward to those challenges and, again, sell your skills, experience and all your assets.

You should also mention how you feel about the company and the job. "Your company has a good reputation in the community and I want to be part of that image. I know I can make an excellent contribution to the goals and objectives of the organization."

An interviewer asked a young man: "What do you hope to gain by taking our position?" The young man blurted out "I love working with people and I can scold them if I have to,

and I can really lay down the law with them if I have to!"
Not a good response from someone who loves working
with people!

If you are asked the question: "Why should we hire
you rather than one of the other candidates?" don't
answer with "I don't know the other candidates"
or "The other candidates may have more years of
service or skills." And, never answer that question
with, "I really don't know!" Don't even mention the
other candidates. Talk about your strengths and skills
and what you can do for the company. You should
focus on how you see yourself succeeding in the
position, and why:

- "My work record speaks for itself."

- "I am a fast learner."

- "I work very well under pressure."

- "Because of my learned skills, I know I can fulfill
 the requirements of your position!"

"A wise man will make more opportunities than he finds."
— Sir Francis Bacon

9. YOUR TURN!

Near the end of the session, the interviewer may ask if you have any questions. If you do have some that you feel must be answered, limit them to no more than three, make them brief, appropriate and relevant to the job or the company.

First impressions are very important, but your final impression counts heavily, too. Don't sabotage a successful interview with a faux pas. At the end of an interview, a young woman asked a male interviewer: "Would I be expected to sleep with you and the other men in the company if I get the job?" Oops, and she wasn't kidding!

Resist asking why the previous person left the job. If it was a positive exit or promotion, the interviewer may tell you – if it was less than perfect, you won't be told.

If you have a burning need to ask about what your future with the company may be, an appropriate way to phrase it might be: "In several years, if I have performed satisfactorily, what might be in my future?"

You will hear a variety of answers to that question. It may give you an idea of what to look forward to or what you don't want to look forward to.

If you hear that there is no upward mobility in a small company and you want to move quickly up the ladder, you may decide this not the company for you. Listen carefully to the response, and watch the body language. You may have stumped the interviewer or panel member. That may be a clue for you to cross that employer off your list.

Another question you might ask, if you think you haven't given enough information about yourself, is: "Have I told you everything you need to know about me or can I answer any more questions?" If the interviewer has additional questions he/she may ask for more information. If there are no other questions, you will be told that as well.

No Questions? Make a Closing Comment!

If everything is clear about the position and the company, and you have no questions about any important details, you can say something like: "I have no questions but I would just like to make a closing statement."

Now would be your last opportunity to sell yourself.

Speak with confidence and self-assuredness. Keep your comments brief, but talk again of what you can do for the company or how your background and experience will be of benefit to the job and the organization. Say only what you believe you are capable of doing. When you are finished with your statement, thank the interviewer or panel for their time.

*"Men are not to be judged by what
they do not know, but by what they
know, and by the manner in which
they know it."*

— Marquis de Vauvenargues

10. Make a Timely and Polite Exit!

It's important to know when the interview is over. If the company representative starts to shuffle papers, or looks at his/her watch or stands up and moves toward the door, those are pretty obvious hints you should finish talking and make a fast but polite exit. Always thank the interviewer(s) for the time you were given.

No matter what book you read or who advised you to ask, "Do I get the job," don't do it! Most interviewers may have to talk to a boss, a manager or some higher authority regarding the interview process.

On the other hand, if the person doing the interview is able to offer you a job on the spot, you will know it. If it is a position you really think you want or need, accept it at that time, but don't accept the job if you have any doubts about whether you can do it or you have reservations about the company.

If there is no offer, be very polite and ask when you might hear from the interviewer again. You can ask, "May I call you in a few days to learn the results of

this interview?" Watch for the reaction. If you are told, "No, we will let you know..." in a few days or a couple of weeks, or whenever, don't push. If the interviewer tells you "no phone calls," don't call. Be aware, your call may turn good vibes into negative ones. If you are a pest before you are hired, will you be a pest as an employee? Of course, if you are instructed to call within a certain number of days, do it!

11. No After-Interview Regrets!

Well done, you survived the interview!

You prepared, you followed through and you gave it your best shot!

Now DON'T beat yourself up with doubts, fears and recriminations—the old "I should have said" or "could have said" will only make you miserable on the way home from the interview!

We have an uncanny ability to berate ourselves. We are our own harshest critics. No one is perfect and there are no perfect interviews. Focus on the fact that you did the best you could at the time, and that you answered the questions with truth, sincerity and confidence. That alone will work in your favor.

When I interviewed for my last position, the position from which I eventually retired, I was sure I had failed miserably during the interview. In fact, I did fail and became my own worst enemy. I berated myself for fumbling through the entire process. When I reflected later that night, as sleep eluded me, I was certain my handling of the interview was

terrible and very poorly delivered.

When I was called back for a second interview, I was shocked! I went back expecting to be told gracefully that I was not selected for the position. I was wrong. After I was hired, and years later, I was talking to the company CEO about my hiring. He teasingly told me, "You were the best of the worst!"

Interviewing for a job is a job in itself. Give yourself credit for doing everything you needed to do to shine at the interview. And don't be hard on yourself if it turns out that you didn't get the job.

There are many reasons why one person is hired over another, and they are out of your control. The job probably went to the applicant who had the exact skills and qualifications they were looking for. Keep your chin up and keep moving forward until you find the right job for you!

One of my granddaughters recently went through a number of interviews before she found the job that best suited her experience and background. She had become quite discouraged, but she kept at it until this job came along. After many discussions with me, her parents and other family members and friends, she learned where she may have failed and therefore improved her interviewing skills. To her credit, she

persevered. Now she is satisfied that all the work of interviewing was worth it in the end.

"It is well to think well; it is Divine to act well."

— Horace Mann

12. Follow-Up Do's and Don'ts!

A follow-up note of thanks for the interview is very
appropriate. The interviewer will be grateful for
your simple gesture of appreciation and, if you are
qualified, the note alone may solidify you as a definite
candidate for the job.

If you are concerned that you have not heard from
the company or interviewer and it has been more
than a month, do not, under any circumstances and
no matter who tells you to do it, DO NOT by-pass
the interviewer and talk to someone else in the
company!

Don't try to wiggle your way into the manager's
office or pull the "I know the boss's daughter"
routine. Trying to circumvent company procedures
could be your downfall. If you hear nothing from the
company after a month, you can probably assume
that you did not get the job.

SECTION IV

OUT OF WORK DUE TO A MEDICAL CONDITION

"Joys are our wings, sorrows our spurs."

— Jean Paul Richter

SECTION IV

OUT OF WORK DUE TO A MEDICAL CONDITION!

Revealing everything is not necessary!

If you have been out of work for an extended period of time because of an operation, injury or illness, it is not necessary to provide the interviewer with a blow-by-blow description of your physical condition.

Before you begin job hunting again, ask your doctor for a signed release, listing any restrictions and stating that you are physically able to return to work.

Then when you are well enough to resume work you can explain the lapses in your work history in a very simple way: "I was ill for a time but I am now physically fit and ready to get back to work!"

Presenting the signed doctor's release will be confirmation to the interviewer that you have, in fact, seen a doctor and you are physically capable of performing again in a work environment.

Revealing that you are a cancer, heart attack or a serious illness survivor can be discussed once you get the job. Speaking about it now is providing way too much information.

If there is an obvious sign of a disability, such as a seeing-eye dog, a cane, a missing limb or a wheelchair, the interviewer may ask if you require a reasonable accommodation. If you do, then he/she can ask what type of accommodation you will need and other related questions.

If there is no obvious sign of a disability, the interviewer cannot ask if you have one, he/she can only ask if you can perform the essential functions of the position. In today's employment world, there are laws that protect persons with a disability.

SECTION V

CONGRATULATIONS! YOU GOT THE JOB!

*"Perseverence is failing nineteen
times and succeeding the twentieth."*
— Julie Andrews

SECTION V

CONGRATULATIONS! YOU GOT THE JOB!

Now the real work begins and it's time to prove that the right decision was made in hiring you.

In any large company, you will likely have a probationary period during which your supervisor will pay close attention to your performance. He/she will observe how well you complete your assigned tasks and how well you interact with your co-workers and others within the workplace. In a small company, there may not be a probationary period but the boss or immediate supervisor will be observing your performance until he/she is convinced you can do the job.

Each day, your goal is to be a productive member of the team and fulfill the promise you exhibited during the interview. Act professionally and strive to be a model for other employees. Be the good example of efficiency, cheerfulness and helpfulness. It will identify you as someone willing to go beyond the expected

norm. A positive and productive work ethic will secure your employment and advance you in the organization.

Here are some final tips and advice that can help you keep the job you've worked so hard to acquire:

- One of the most important aspects of being a good employee is being on time at the beginning of your workday and after your breaks. It speaks volumes about your character and commitment to your job.

- Respect your employer, your supervisor and your co-workers. Do not disregard company policies and always abide by all the rules. JUST DO YOUR JOB!

- Don't listen to the tales other employees tell you. If you have a question about the work or your work schedule, talk to a supervisor, don't rely on hearsay. You may receive personal biases that could get you into trouble.

- Don't take long breaks or ignore the tasks you have been assigned to do.

- Sick-leave isn't meant to be a "personal holiday." Stay home if you are ill, but don't take advantage of the company's sick-leave policy. When you are ill, call your supervisor and relate the circumstances. Going into work when you are contagious or

truly unable to perform your duties is unfair to your co-workers and an absolute taboo. But, be sure to follow company procedures.

Unless there is a company layoff, over which you have no control, you will probably keep your job as long as you want it. Ignore the rules, do your own thing, be a difficult and argumentative employee and you will probably lose that job quicker than you can imagine.

It is hard to believe, but the following incidents happened, and the employees were soon ex-employees!

The administrative assistant who spent all his earnings on drugs, and the only way he could eat was to raid the lunches of his co-workers...

A file clerk who did her laundry in the lunchroom sink and hung it on a clothesline around the outer edge of the room...

The truck driver who crashed the company truck and neglected to tell his boss about the incident until the police tracked him down, on the company premises...

A custodian who was so nervous his first day on the job that he refortified himself with four alcoholic drinks before he showed up for work...

The retail sales clerk who avoided waiting on customers because they interrupted her ability to keep the product shelves in order....

I could go on and on about the hordes of horror stories I have witnessed in my years in the employment field. When I was young, I was outraged by the inappropriate behavior of applicants in the pre-employment process and employees in the workplace. As decades passed, I became less and less shocked by the odd and unusual. I learned that people say and do the strangest things!

Thank you for reading this book. I wish you good luck in the future in whatever you endeavor. If you change jobs again, remember to do your homework before you interview. If you obtain another job, be the best employee you can be once you are hired.

SECTION VI

JOB HUNTING/COVER LETTER/ RESUME WRITING REFERENCES & RESOURCES

*"The men who try to do something
and fail are infinitely better than
those who try to do nothing and
succeed."*

—Lloyd Jones

SECTION VI

JOB HUNTING/COVER/LETTER/ RESUME WRITING REFERENCES & RESOURCES

Modern day job hunting has gone high tech!

The internet provides job seekers with a comprehensive clearing house of employment listing sites, free resume postings, links to corporate job boards and a vast array of information on employment trends, career tips and "hot jobs." And, they are all just a search engine entry and mouse click away!

From finding a part-time job in Pasadena, California, to applying for a Marketing Manager position in Massachusetts, the internet brings the local, nationwide, and even the international job market to you. An internet search engine will also provide links to a major company's current employment listings.

Do you want to work for ABC Television, or their owners, The Walt Disney Company? You can find

job opportunities by simply typing ABC TELEVISION JOBS in the search bar of any search engine. Looking for a data entry position in Detroit? Type in DATA ENTRY JOBS DETROIT. How about something adventurous in Alaska? Type in ANCHORAGE ALASKA JOBS.

The point is that you can now access information about any career path you want to take, or you can explore what is available at a company you've always wanted to work for, just by making the simplest of internet searches.

The internet is loaded with job listing sites providing literally any type of employment position in any location. These sites also offer free resume posting, provide links that send your application/resume by e-mail direct to an employer, and present articles, news, advice and guidelines for pursuing any employment path. Also, sites usually provide a free registry that will e-mail you daily notices on employment opportunities specific to your interests.

Here are some of the leading job-listing sites. Consider them your personal "employment agencies" helping you to find the job you want.

www.job-hunt.org
This site offers what may be the most comprehensive

listing of useful internet-accessible job-search resources and services on the Web (with links to screened job search sites and career resources). Job-hunt has been voted a "Top" job-hunting website by the likes of Forbes and PC Magazine. The extensive site is also a definitive educational source with guides and information on making the best use of other job-hunt sites. Their articles offer encouragement and advice on the basics of job hunting.

www.careerbuilding.com

This is a vast job search service with listings across the U.S. You can search by industry, company, type and location, and post a resume for employers to view. Also includes links to career advice and job fairs.

www.monster.com

This website lets you search worldwide jobs, post your resume, or network with professionals. The "Job Finder" section lists openings by region and category. Career help articles, advice and free resume writing information is also available.

www.vault.com

Offers career information, including industry and interview guides, employer profiles, employee message boards and industry-specific job boards. Vault offers free job alerts, listings and newsletters, and has an extensive international section. This is a

good place to find information on the company for which you want to interview.

www.craigslist.org

This site provides local, nationwide and international classifieds and forums listing an eclectic array of jobs, housing, goods, services, advice and just about anything else.

www.indeed.com

This is a Google-like search engine for local job listings. Links to over 500 job sites, newspapers, associations and company career pages accessed by a keyword and location search.

www.jobing.com

Enter the zip code of the area in which you want to job hunt and access job lists, links, resources, and company recruitment videos.

The Yahoo! Directory and HotJobs

Enter YAHOO JOB LIST in any search engine and access the Yahoo! Directory for employment and business listings. Here are links to hundreds of sites specific to career and employment objectives. Yahoo! also hosts a HotJobs site: **www.hotjobs.yahoo.com** which posts jobs by company, industry, worldwide location and salary.

Local Job Banks

Enter JOB BANK and the STATE in which you seek employment in any search engine to access a wealth of government, state and private industry jobs, along with links to career-specific job list sites in your state. Don't discount these employment offices. Many people shy away from them because they provide food stamps, unemployment benefits, and other services to the needy. I have personally worked with our local government-sponsored job bank offices and there are exceptional people working to assist applicants. Employment counseling, advice and resume services are also available on the job bank sites, which are run by the state's economic development and human services departments.

In addition to Monster.com and your state's job bank, just type "resume writing" into any search line and you will find many sites that offer free advice on how to write a cover letter and a resume.

If you do not have a computer, you can check your local telephone book for your state's economic services or you can make a trip to the library. Most libraries offer free internet access and resource books.

Job hunting is a job in itself. Take advantage of the many resources available, be methodical and diligent

and don't get discouraged. With persistence, you will unearth a position that suits your talents and desires; and with what you've learned from this book, you'll be prepared to shine at the interview!

About the Author

Rachel Ingegneri has spent over 36 years on the other side of the desk as a Personnel/Human Resource executive interviewing every possible type of candidate. Her responsibilities have included executive and rank and file recruiting, counseling, employee benefits, workers' compensation, writing and conducting employee training programs and a variety of other administrative duties, including and not limited to kitchen duty, hall monitoring and a myriad of other nameless tasks.

Rachel attended Pima Community College and the University of Arizona and was a certified handwriting analyst. Although now formerly retired, she currently consults for a number of Arizona companies. Rachel and her husband reside in Tucson, Arizona.

Other books in the
10 Minutes 2 Success series:

Ten Minutes to the Audition
 by Janice Lynde

Ten Minutes to the Pitch
 by Chris Abbott

Ten Minutes to the Speech
 by Vance Van Petten

For more information,
visit: www.Tallfellow.com

Tallfellow®Press
Los Angeles